Sam Stephenson

W EUGENE SMITH 55

The legend of W. Eugene Smith arose from the time when he was a young, fearless combat photographer in World War II who made sensitive, humane photographs on the frontlines. Since then the legend has grown larger, become more comprehensive, more entrenched, and is sustained by those newly discovering him two decades after his death in 1978. But, if it was his intention to leave a legend instead of the real W. Eugene Smith, then surely he would have destroyed all of his work, except for the one or two dozen pictures that largely define his photographic legacy today. Instead, he left behind some 3,000 master prints, several hundred thousand 5 x 7 work prints, 1,600 reel-to-reel audio tapes, 25,000 vinyl music records, 8,000 books, many volumes of project files, hundreds of letters, thousands of 3 x 5 notecards with scribbled notes, and just $18 (according to his biographer, Jim Hughes, in *W. Eugene Smith: Shadow and Substance*). From all this, the real W. Eugene Smith becomes more improbable than the legend.

Born on 30 December 1918 in Wichita, Kansas, Smith was introduced to the camera as a youth by his mother, who enjoyed taking snapshots of the family. He took to it quickly and began taking photographs professionally at the age of fifteen for local newspapers; his photograph of the drought-dried bed of the Arkansas River was even published by the *New York Times*. However, his teenage years were marked by tragedy. In 1936, his father, whose grain business had been lost a year earlier in the Great Depression, drove to a hospital parking lot in Wichita and blew open his stomach with a shotgun. It took several hours for him to die, after doctors had tried in vain to save him with a blood transfusion from the 17-year-old Eugene.

Smith went to the University of Notre Dame on a photography scholarship, but dropped out after a year and moved to New York City in 1937 to become a

full-time professional photographer. He was fascinated by World War II, but was denied entry into Edward Steichen's naval photography unit because of bad eyesight (he wore glasses) and a limited college education. Still, the persistent Smith managed to obtain various wartime assignments for *Life* magazine and other publications, and he photographed the war for three years, mostly in Japan and the Pacific theatre. On the frontlines, Smith got as close to the soldiers as he could, physically and emotionally, and his published photographs allowed viewers to feel the nature of warfare intimately. While photographing US army foot-soldiers on a mission in Okinawa in May of 1945, he was hit by shell-fire, hospitalized with critical injuries to his head and one arm, and disabled for more than a year.

Between 1946 and 1954, Smith undertook a broad range of assignments for the pre-television powerhouse of American journalism, *Life* magazine, where he was a well-paid staff photographer. His subjects ranged from a black nurse-midwife in rural, poverty-stricken South Carolina, to Dr Albert Schweitzer in equatorial Africa, among many other projects. In each case, Smith would spend several days or weeks observing a location and mingling with the people before he took his first photograph. He wanted to get to know his subject intimately, but, at the same time, become so familiar that he could melt into the background and capture images unobtrusively. Despite the generally accepted doctrines of objective journalism, Smith never attempted to maintain a personal or professional distance between himself and his subjects. A photograph was an image that he saw, felt and experienced, and he wanted others to experience the moment as he had.

In his career with *Life*, Smith undertook more than fifty assignments, but his relationship with the magazine was tumultuous. He rejected *Life*'s notion that

the photographer's job was finished when the negatives were completed: his negatives were the raw material which only he could nurse into proper print form or arrange effectively in layouts. No honourable editor would anonymously modify a poem without consulting the poet first, Smith argued; why should photographers be treated differently? *Life*'s editors countered that Smith was unreasonable and that the other staff photographers did not have such a problem with the editorial policies. Each published photo-essay was preceded by an excruciating exchange of insults, ultimatums and compromises as Smith and the editors fought for control. Yet the photographs were moving and beautiful, and the essays were highly praised by other photographers, critics and the magazine's huge readership. The relationship between Smith and *Life* staggered forward from year to year, assignment to assignment, with bitterness and resentment escalating in the wake of each successive essay.

It was during this period that Smith's legend began to take root. Aesthetically, his pictures began to go far beyond the principles of journalism and into the realm of impressionistic art, as he began manipulating scenes (by posing shots) and negatives (by bleaching and other techniques to achieve a dramatic chiaroscuro) in order to present a visual rendering of the non-visual. He clung ferociously to his artistic vision, insisting that the camera was a 'damn liar' and that truth was much more intangible than just facts, or mere appearances. In a book by sculptor Auguste Rodin, *On Art and Artists* (1957), Smith heavily underlined the following sentence and wrote 'This is the epitome of journalism' in the margin beside it: 'When he softens the grimace of pain, the shapelessness of age, the hideousness of perversion, when he arranges nature – veiling, disguising, tempering it to please the general public – then he creates ugliness because he fears the truth.'

Smith's maverick style and artistic integrity made him a hero and an inspiration to many, but a pariah (justifiably, sometimes) to conventional concerns. Word began to spread, through *Life*'s powerful channels, that Smith was impossible to work with. He was known to spend several days working non-stop on a single print while the magazine waited. Furthermore, his photographic obsessions – and chemical dependencies – began to cause havoc in his personal life. He spent more and more time in his studio and less at home with his wife, Carmen, and their four children. In September of 1950, exhausted from working on what was to be his classic *Life* essay, 'Spanish Village', Smith was arrested while walking aimlessly in the streets outside his studio, wearing only boxer shorts, according to Jim Hughes. He was committed to Bellevue psychiatric hospital and a private psychiatric clinic for several weeks. While institutionalized, according to Hughes, Smith told a friend, 'I got this licked. I know what these people want.'

Once out of hospital, Smith went on to create another of his landmark photo-essays for *Life*, 'Nurse-Midwife', which was published in December 1951. The essay was about Maude Callen, a black nurse-midwife in rural South Carolina. The essay and Mrs Callen were remembered with great fondness and warmth by Smith for the rest of his life. But his days with *Life* were numbered. During his final two years there, 1952–4, Smith completed only six assignments, as he expended ever-growing amounts of time and film on jobs that others deemed routine. On assignments, such as the Metropolitan Opera in 1952 or migrant workers in Michigan in 1953, Smith would spend months making hundreds, if not thousands of superb, exacting photographs on *Life*'s account – many more than the magazine needed or wanted – all for a potential layout of just a few pages. Then he would bicker with the magazine's editors over the usage of his images in

those layouts. The structure of a weekly magazine could not sustain the sort of ambitions that were welling up inside him. *Life* wanted a reliable photographer who could accept the boundaries of specific assignments and meet deadlines; Smith wanted to tell the complex story of the world with photographs. The break-up was inevitable.

Smith's excessive behaviour was not restricted to photography. He estimated, in various letters from the mid-1950s, that he owned 25,000 vinyl music records – of all kinds, but especially classical and jazz – and some 5,000 books (there were at least that many when his archive was deposited at the Center for Creative Photography at the University of Arizona in Tucson). Friends, neighbours and family members reported that he would listen to music all day and night, frequently in his darkroom, at thunderous volumes. In World War II, he took records and a portable phonograph to the frontlines, often flying from one ship to another to pick up boxes of his records that were spread around the South Pacific. His photographic assistants said that he would sit outside his darkroom reading Joyce, Faulkner, Rilke and O'Casey for up to ten hours at a time, while they would bring out every print that was made so he could examine it. His consumption of large doses of alcohol and amphetamines allowed him to work in three- and four-day stints without sleep, then collapse in a heap of exhaustion. Throughout his life, he would type 4,000–6,000 word letters to family, friends, even casual acquaintances – often several different ones in a day. These stream-of-consciousness writings revealed his uneasy spirit; for instance, in a letter to a former photographic assistant in late 1953, he wrote, 'I am in a mood of flip-pant sorrow, restlessly eager to plunge all the way into a story, to feel the sharp

By early 1955, Smith had quit *Life* and joined Magnum, the prestigious co-operative agency for photographers, through which he would seek freelance assignments. His first major job was for historian and editor Stefan Lorant, who was working on behalf of civic leaders in Pittsburgh to put together a large book commemorating the city's bicentennial. The three-week assignment was to produce 100 prints for the book's chapter on contemporary Pittsburgh. When Smith arrived, Lorant was astounded to see him unload some twenty pieces of luggage, a record player and hundreds of records and books. Smith spent the first month wandering around the city and reading its history, absorbing everything that he could. The informal deadline of three weeks passed without a click from his shutters.

Smith took photographs of Pittsburgh for the better part of a year, exposing more than 13,000 negatives. After a vicious battle with Lorant, not unlike the ones he had had with *Life*, Smith finally met his obligation by delivering several hundred prints to Lorant to use as he pleased in his book. He left Pittsburgh in late 1955 and, aided by two Guggenheim Fellowships, spent the next three years obsessively developing Pittsburgh prints and working on layouts. Smith gradually pared the images to a set of approximately 2,000 5 x 7 work prints, which he painstakingly arranged, rearranged and pinned to large bulletin boards all over his studio. He considered these boards, in their constant, agonized state of flux, to be his 'Pittsburgh essay'. In his notes and letters, he referred to this body of work as his 'greatest' or 'finest' set of photographs. 'If nothing else, this Pittsburgh layout has the tremendous unity of my convictions.' It was as if he was drawing on everything in his life for this essay; all experiences, books, music, paintings and influences. There was an urgency to create a *magnum opus* that would show *Life*'s editors what a visual revolutionary they had been constraining all along.

Smith eventually brought approximately 600 of his Pittsburgh images to a master print form, a herculean accomplishment observable today, print-for-print, in his archive at the Center for Creative Photography and in the collection at the Carnegie Museum of Art in Pittsburgh. But Smith was never able to put forth the Pittsburgh essay in a manner that satisfied him. Despite desperate financial problems for him and his family, Smith refused up to $20,000 (approximately $95,000 today) from *Life* and *Look* magazines for the pictures, according to Jim Hughes, when they would not agree to his demands for editorial control. The Pittsburgh project was unfinishable, Smith's ambitions perhaps unreachable. While discussing his Pittsburgh work in several letters from the period, Smith compared himself to the writer Thomas Wolfe, who was notorious for submitting bold, eloquent, but bloated, perhaps reckless manuscripts which required comprehensive editing before they were ready for publication. Smith wrote, 'And part of [my Pittsburgh work] is like Wolfe being the greatest of our writing failures because he tried with such tremendous talent and tried so hard, harder than the rest of us.' Of Wolfe's massive enterprise, William Faulkner said, with implications of both awe and disdain, that Wolfe was trying 'to put all the experience of the human heart on the head of a pin'. Smith was trying to do the same.

In the mid-1970s, not long before he died, in an autobiographical diatribe Smith wrote: 'I think I was at my peak as a photographer in, say 1958, or so. My imagination and my seeing were both, I don't know ... "red hot" or something. Everywhere I looked, every time I thought, it seemed to me it left me with great exuberance and just a truer quality of seeing. But it was one of the most miserable times of my life.' He finally put Pittsburgh aside in late 1958 after eighty-eight of the pictures were published in *Popular Photography*'s *Annual* in a

layout Smith called a 'debacle'. He was paid only $1,800 for the work. Although he kept a Pittsburgh book on his list of projects for the next decade, he never returned to it.

A year earlier, in 1957, while in the throes of his Pittsburgh saga, Smith had moved out of his home and into a dilapidated loft in New York City's wholesale flower district, virtually abandoning his family. The loft had been an after-hours haunt of jazz musicians since 1954. Smith befriended David X. Young, a young, abstract expressionist painter who had started the loft scene, and Hall Overton, a musician and loft resident who had a longtime collaboration with pianist and composer Thelonious Monk. Young and the musicians who visited the loft – staying up all night, tuning out the workaday world, driven by passion rather than money or fame – inspired Smith during this harrowing stretch in his personal life and provided focus for his energy. Over the next seven years, he made about 20,000 photographs inside the loft and another 20,000 out of his fourth-floor window of life on the street in the flower district. Moreover, he wired the loft like a recording studio and made more than 400 reel-to-reel tapes of the jazz jam sessions, which included the likes of Thelonious Monk, Zoot Sims, Bill Evans and countless others. In addition to the jazz tapes, Smith also recorded 1,200 tapes of telephone calls, various conversations in the loft, radio and television programmes, his own monologues and other oddities. After the labyrinthine Pittsburgh crusade, Smith retreated to the loft and compulsively documented this underground, swinging corner of the world.

The image of Smith maintained by the loft musicians contrasts with the one that still prevails today in many photography circles, where his compulsions are judged to have been driven by megalomania. Guitarist Jim Hall recalls: 'There

was one night when [guitarist] Jimmy Raney and I had a series of gigs at the Village Vanguard [a New York jazz club]. Jimmy's wife Lee and my wife Jane took a bunch of photos of us playing. Afterwards, we took the film over to the loft and asked Gene if he could help develop the pictures and make prints for us. We were a bit uncomfortable asking the Master if he'd help us with our piddly photographic work. It would have been like Gene asking to play with me and Jimmy at the Vanguard. Gene responded with kindness and generosity. He took us into his darkroom and treated our film like it was his film. You'd have thought he was making pictures for *Life*. He was extremely particular about it. That's how he always was.'

Smith, who was forty years old in 1959, befriended a brilliant young drummer named Ronnie Free, who was twenty-three, drawn by their mutual severe drug and alcohol addictions and feverish work habits. Free had a connection at a drug store and gave Smith access to it; Smith let Free sleep on his recliner for more than a year. 'Gene and I swapped goodies,' says Free. 'My favorite amphetamine was a little white pill called Disoxyn, which I shared with Gene. He used to give me what he called "psychic energizers". In those days, if I found a pill on the street I'd pop it in my mouth without even knowing what it was, like it was an M&M or something. I'm lucky to be alive. I found Gene's loft as a way I could get my career and life back on track, because there were some great musicians there, and Gene was generous enough to let me stay. I was virtually homeless. Gene was in a similar situation as me, trying to get everything back in order. He was like a mad scientist. I have no memories of him sleeping, or even sitting down. He worked constantly. He always had an assistant or two around and I never knew where he got the money to pay them. He was as broke as I was.' In a speech at the Rochester Institute of Technology in 1965, Smith mentioned being

inspired by Free's determination while driving some of the loft's greatest jam sessions, including one session which Smith said lasted five days without a break. ('Well,' said Free, when told of Smith's comment about the five-day session, 'Gene tended to exaggerate.').

After putting aside Pittsburgh, Smith began another massive project which was perhaps similarly doomed, in terms of public presentation, by unfathomable ambition. It was a kaleidoscopic, 500-photograph retrospective of his entire career, which he aptly called the 'Big Book', later renaming it after his famous photograph, *The Walk to Paradise Garden*. The book was to be a non-topical, non-chronological visual feast, with images spanning his career; the lyrical link between the pictures was Smith's passion. He and his assistant, Carole Thomas, eventually put the work together in a book dummy, which was, of course, unpublishable. Today, the dummy sits intact in Smith's archive at the Center for Creative Photography.

Smith spent much of the 1960s giving speeches and lectures at various schools and conferences, which he taped. In many of them, and in many of his letters from the period, his tone was of elegy and wry retrospect, as if, while still only in his mid-forties, his career was over. In many of his speeches he talked about his visions for the photographic essay – the multi-layered visual poem – and efforts to create a *magnum opus* with 'Pittsburgh' and the 'Big Book'. In one speech to a group of students in the early 1960s he was asked: 'How can you be a practising photo-essayist and not be working for *Life* magazine?' Smith paused, stammered and finally answered, with a self-effacing humour, 'Gee ... uh ... I don't know.' The audience laughed heartily. Smith laughed with them.

In 1968, Aperture gave Smith the opportunity to publish a monograph with 120 pictures, which was entitled *W. Eugene Smith: His Photographs and Notes*. Still just fifty years old, the commitment and attention Smith received seemed to revive and refocus him; his letters from the period are more positive and upbeat than before. He harboured no intentions of turning the monograph into anything other than a portfolio of his career. He followed the monograph with a massive, highly successful exhibition at the Jewish Museum in New York in 1971. The exhibition, 'Let Truth Be the Prejudice', contained, according to Jim Hughes, 542 pictures. The show was a stunning account of Smith's thirty-five years in photography. On opening night, with celebrities and fans gathering at the museum, Smith was still in his loft frantically making prints and having assistants deliver them at the last minute. Smith showed an utter disregard for the sterile conventions of museum shows, using mismatching frames and mounts, if any at all, and crowding the pictures in cinematic sequences and juxtapositions. In a review of the exhibition, critic A. D. Coleman wrote: 'Matters such as print quality, composition, and tonal values are entirely irrelevant. So is the term artist, and the concept of print-as-object. What matters is integrity, humility, compassion, compulsion, anguish, and commitment.'

Smith and his second wife, Aileen, a Japanese-American, accompanied 'Let Truth Be the Prejudice' to Japan later in 1971. There they learned of the fishing village Minamata, where the population had been tragically contaminated by a large company secretly dumping its mercury-poisoned waste into the bay. For Smith, Minamata was the perfect epilogue to a career which had largely been spent pointing out, in lyrical terms, the paradoxes and contradictions of human desire and progress. The work, which he completed with critical assistance from Aileen, resulted in the book *Minamata*, which garnered Smith his greatest

worldwide acclaim. The work also resulted in his most iconic individual image *Tomoko Uemura in her Bath*, which many consider to be his masterwork. Its widespread publication, however, ultimately caused Tomoko's family undue pain and, at their request, it was recently withdrawn from circulation.

In December 1975, Smith's doctor wrote a letter describing his patient's physical condition. Smith, aged fifty-seven, had: 'diabetes, cirrhosis of the liver, moderately severe hypertension, chronic venous stasis with stasis dermatitis, cardiovascular disease, and coronary artery disease, with an enlarged heart. The doctor's note concluded with the mandate, 'no alcohol'. It is doubtful that Smith heeded the doctor's mandate. His friends recognized that he was going to die if they did not get him out of New York and into a more stable, healthy situation. His years of little sleep, manic work habits, alcohol and drug dependencies and other dangerous compulsions, had added thirty years to his body.

Jim Hughes, Ansel Adams and a few other of Smith's friends were responsible for his move in 1977 to Tucson, Arizona, where he accepted a teaching position at the University of Arizona. There, in return for his teaching opportunity and salary, the Center for Creative Photography would take over and maintain his enormous, unwieldy archive. Smith had been in Tucson less than a year in 1978 when he suffered a fatal stroke in a convenience store while buying cat food. He was fifty-nine.

When Smith's archive was put together before his death, grant funding had to be raised to ship the materials from New York to Arizona. The shipment weighed 44,000 pounds. William S. Johnson was the archivist in charge of organizing the collection. After spending three years sorting and cataloguing Smith's work

Johnson wrote, 'Perhaps [his] greatest masterpiece is not any one of his photographs, but his overall career.' Johnson added that after looking at all 3,000 master prints, not to mention voluminous work prints, he understood Smith's torment in having to settle for *Life*'s layouts of only a dozen or so pictures. The extraordinary quantities of exacting, beautiful images that Smith left behind, as well as the uncanny audio recordings from the jazz loft and his prolific written archive, provide a staggering portrait of his life. This material tells the story of a brilliant, compulsive documentarian who made a permanent record of his own life through his work. The legend pales next to this record.

Untitled (stacked fruit crates at storefront, fire in barrel, people at right)
1934–43. In this early, undated picture, probably made in New York City, Smith's trademark style of dramatic chiaroscuro is not yet evident. However, this picture does contain a theme which recurs throughout Smith's career: that o humans being dwarfed by something human-made, such as a factory building o social institution. The looming wall in this picture is made of crates filled with fruit and vegetables – healthy nutrients – and the man in the foreground is destroying something in a fire. To render an ambiguous, often contradictory mi of human desires was a lasting aim of Smith's photographic ambitions, often to darkly humorous or ironic effect.

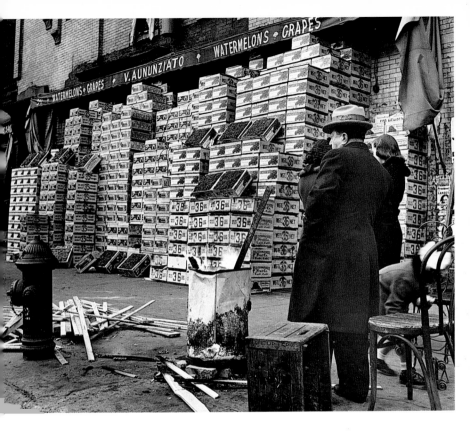

Stranger in Town, 1942. The gravity and passion of Smith's most famous photographs dominate his legacy. But his archive is littered with pictures indicating the wry, deeply ironic sense of humour that many of his non-professional friends say he had. Much of the humour is dark and complex – Kafkaesque – aimed at the folly and ultimate futility of human desire. This picture was published in *Parade* magazine, 29 November 1942. In a lecture at the Center for Creative Photography at the University of Arizona in 1978, shortly before he died, Smith said, 'the happiest years of my life were the early days of *Parade* magazine'.

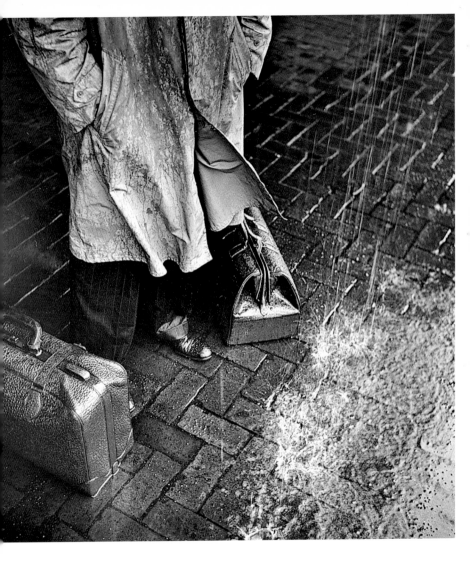

Frontline Soldier with Canteen, June 1944. This picture of American soldiers was made on the frontlines of Saipan and was published in *Life* magazine 28 August 1944. In his war coverage, Smith got as close to the soldiers as he could, befriending many of them. This picture illustrates the virtually two dimensional, cubist juxtapositions that Smith often used.

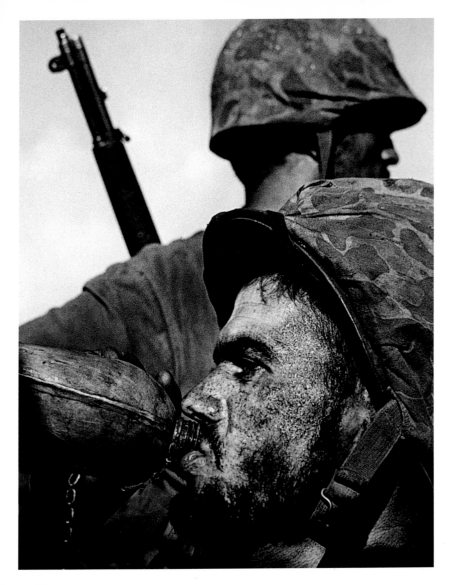

Wounded, Dying Infant Found by American Soldiers in Saipan mountains, June 1944. Smith's wartime photographs have an uncanny way of shifting between morbid destruction and intimate humanity, sometimes within the same picture. It was this kind of lyrical turn that Smith said he learned from music. He often too a portable phonograph and records to the frontlines. As quoted by Jim Hughes in his biography, 'I think I told you,' Smith once wrote to his wife, Carmen, 'that always listen to a record from *Tristan* and a duet from *Parsifal* the night before impending battle.'

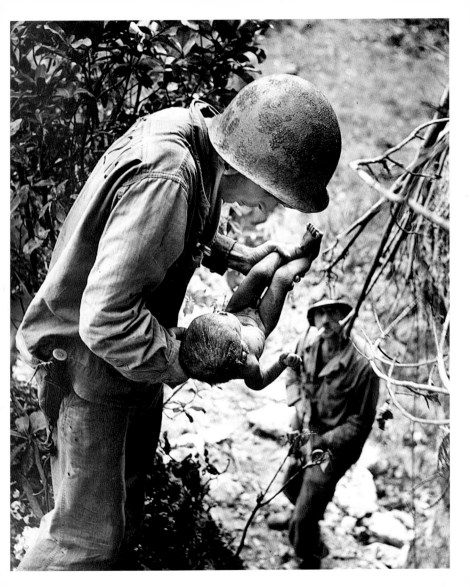

Marine Demolition Team Blasting Out a Cave on Hill 382, Iwo Jima, March 1945

'The bombs exploded and a gigantic eruption of flame, and water, and men and machines filled the air for hundreds of feet around. People shudder and say it is a horrible, ghastly way to die, but it is not – it is a preferred way to die. The only horrible part is death taking those who were so young,' Smith wrote in a letter.

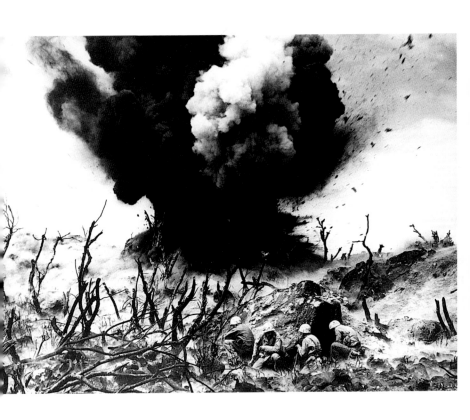

Ship off Okinawa at Sunset (D-Day), 1 April 1945. This picture is from the Allied invasion of Okinawa in April 1945. Smith is not famous for his landscape or seascape photographs, but his archive contains hundreds of outstanding, expressive examples. 'And if you believe that the naval war in the Pacific does not have its long moments of sheer beauty, then you are trying to imagine a constant grimness that just doesn't exist,' said Smith.

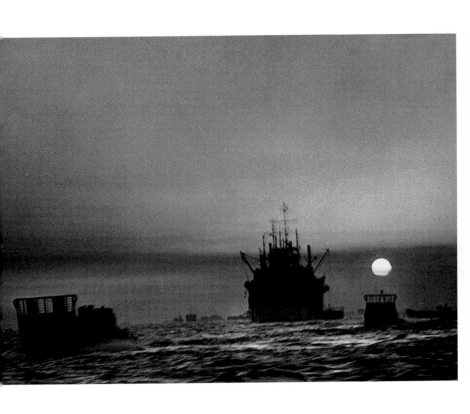

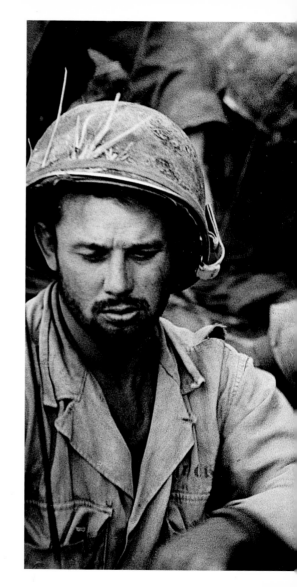

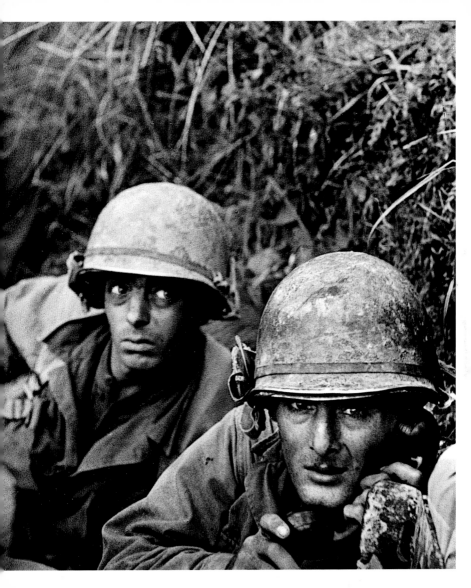

(previous page) **Untitled (three tense soldiers, one on portable phone), Okinawa, April 1945.** Smith was energized by his assignments as a combat photographer on the frontlines. He felt himself to be a peer of the soldiers, not a journalist covering them. His pictures reflect a sensitivity and an intimacy, not only with American soldiers, but with innocent natives of invaded countries in the South Pacific. 'In some ways, it [the war] was a bitter commentary on the equality of all men,' he wrote.

The Walk to Paradise Garden, 1946. After being hit by shell-fire from a bomb on the frontlines in Okinawa on 22 May 1945, Smith was disabled for a year. This was the first photograph he made after lengthy rehabilitation, and was eventually to become his most popular image. The picture provided necessary affirmation of life's journey after the devastation of World War II. The two children are Smith's own, Pat and Juanita, and the picture was posed near their home in New York. The picture, named after one of Smith's favourite pieces of music by Frederick Delius, was the closing image in Edward Steichen's legendary 'Family of Man' exhibition at the Museum of Modern Art in 1955.

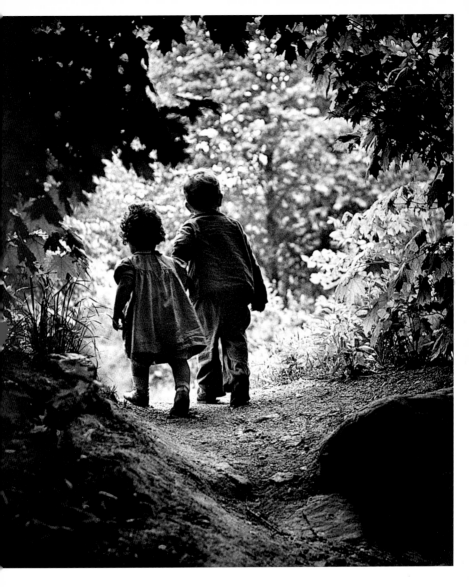

Near Taos, New Mexico, 1947. This picture is from an unpublished essay on the American state of New Mexico, which Smith created for *Life* magazine in 1947. The essay contains numerous outstanding images from a variety of settings. This picture – the fallen cross seen from outside a fence – indicates Smith's ambivalent feelings about religion and death.

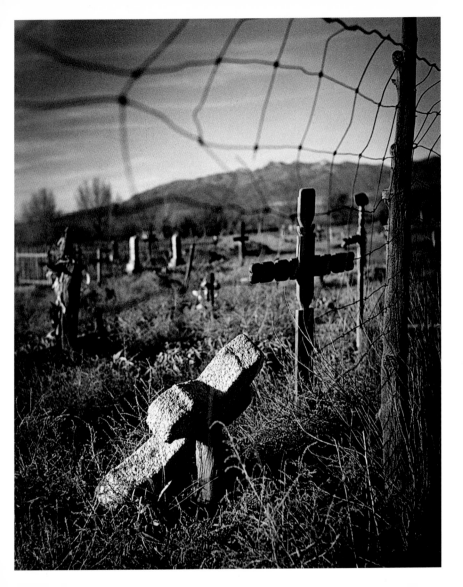

Untitled (barefoot girl seated with guitar in front of log house), 1947. This picture is from Smith's 1947 essay entitled 'Folk Singers'. It is from a folk music festival in Asheville, North Carolina. Music was one of Smith's greatest passions and he photographed musicians throughout his career. He loved almost any form – classical, jazz, opera, flamenco – and he often taped folk music programmes from the radio. If this essay was unremarkable, it was because it lacked the dramatic tension of his landmark essays to come. However, it is indicative of his warm rendering of the folk musicians.

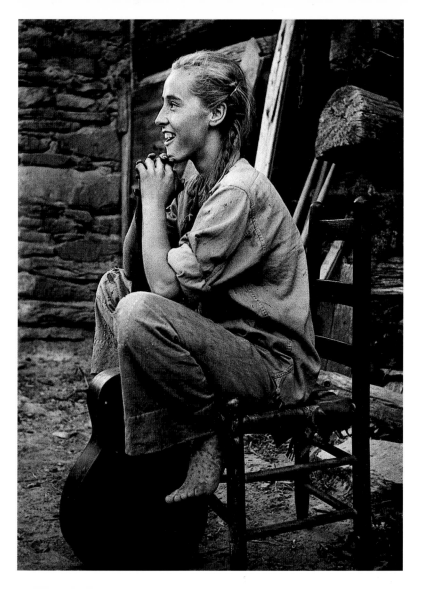

Charles Ives, April 1948. This photograph of American composer Charles Ives was published in *Life* magazine on 31 October 1949. Smith repeatedly stated throughout his life that the rhythms, movements and harmonies of music were primary influences and inspirations for his photography. The dissonant beauty of Ives' music made it a Smith favourite. This is one of the rare photographs Smith made in his entire career with the subject looking directly at the camera.

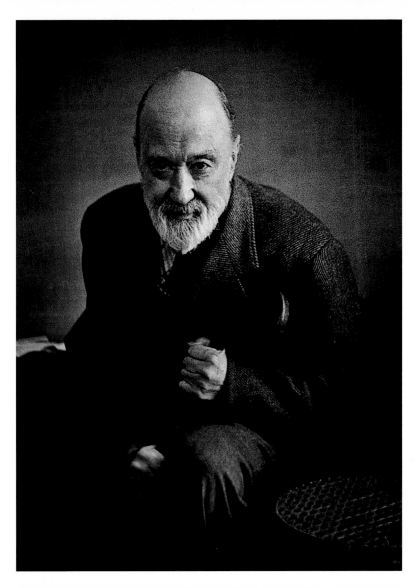

Dr Ceriani Going from House to Hospital, 1948. Smith's 'Country Doctor' essay was a landmark in photojournalism. It was the first photographic story for a major publication in which the photographs were not made according to a strict script created by the publisher. With this essay, Smith firmly established his working style of living within an environment, no matter how long it took, until he could fade into the background and unobtrusively capture intimate pictures instinctively. *Life* magazine, with its enormous pre-television circulation, was a window-on-the-world for many people, and Smith's essays made a big impact on the readership. This was the lead picture of Smith's spread on Dr Ernest Ceriani of Kremmling, Colorado.

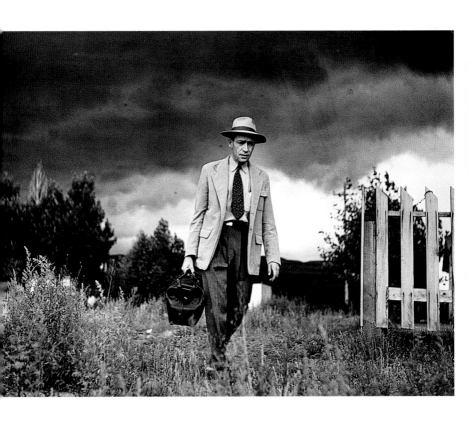

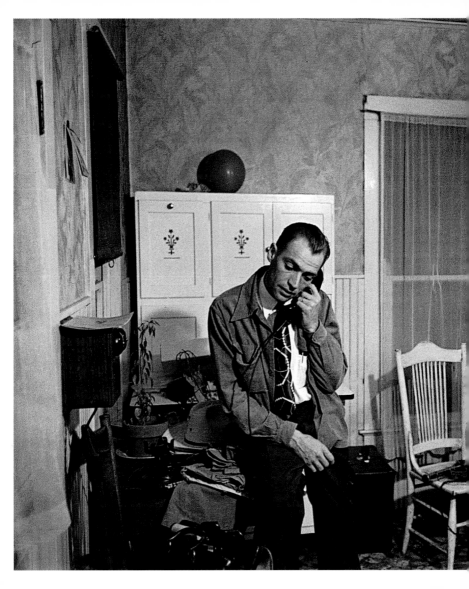

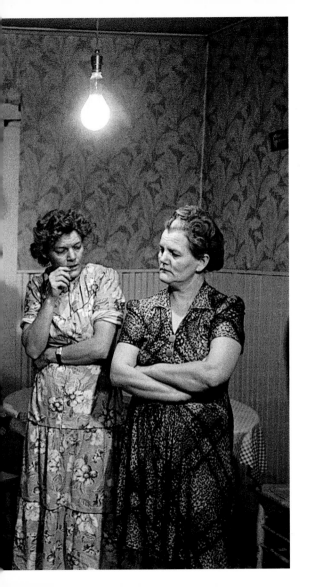

(previous page) **Untitled (Dr Ceriani on phone, two worried women standing nearby), 1948.** One interesting recurrent element throughout Smith's career is the lightbulb hanging from a wire in an ordinary, perhaps drab room or hallway, making the available light source a prominent part of the picture. This is from 'Country Doctor'; Dr Ceriani is pictured telephoning a priest, asking to meet him at the hospital after a patient's death.

Untitled (American Theatre Wing School – overview of group seated in circle, raised platform in background), 1949. This picture of a theatre production company in New York City is from the essay 'Hard Times on Broadway' (February 1949). Smith was as fascinated by the theatre as he was by music. He often listed Sean O'Casey, Tennessee Williams, Eugene O'Neill and other playwrights as influences on his visual style. This picture is also an example of Smith's ongoing intrigue with human groups, whether formally or informally arranged.

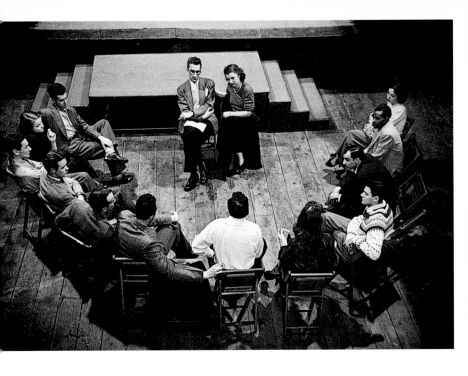

Untitled (small monkey being put into apparatus by person in surgical clothes another person looking on), 1949. The human endeavour of science is another theme that surfaced regularly throughout Smith's career. He cast a rather sceptical eye over human scientific achievement, not saying that it was without merit, but that human striving in all its forms is ultimately ambiguous, leading to the same end. Of this picture, from the 1949 essay 'Life Without Germs', Smith said, 'There is a relationship in many of my pictures, a rhythm you can feel between the needs of society and science. Progress both helps and harms humanity, and I am drawn to the struggles of man to move forward and backward at the same time.'

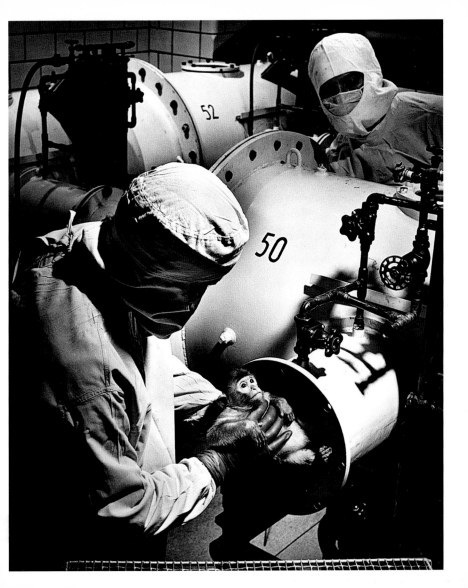

Youngstown, Ohio Steel Mill, 1949. Smith made spectacular, expressive photographs of heavy industry throughout his career, not just in his epic Pittsburgh project. This photograph is from another 1949 essay, 'Taft and Ohio' about Senator Robert Taft and his diverse constituency. With the magnificent flames and sparks engulfing a man pushing a modest wheelbarrow, this is an example of Smith's growing usage of ferricyanide bleaching techniques in his printing process, meant to highlight stark contrasts between dark and light.

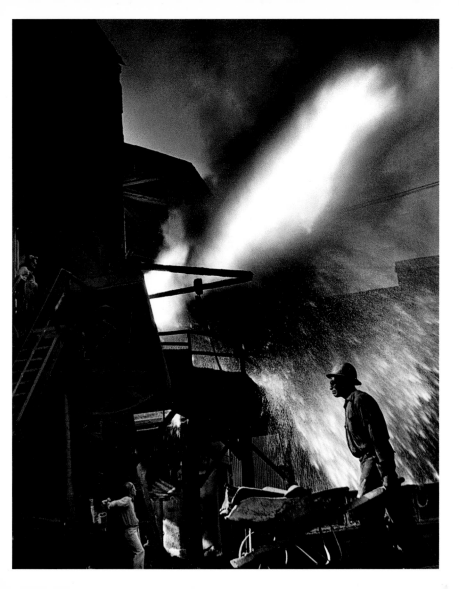

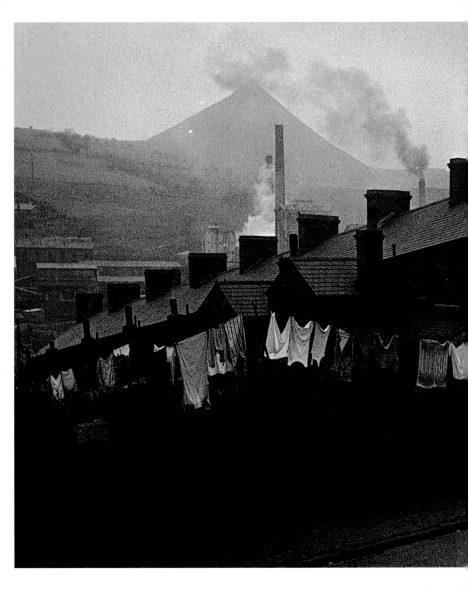

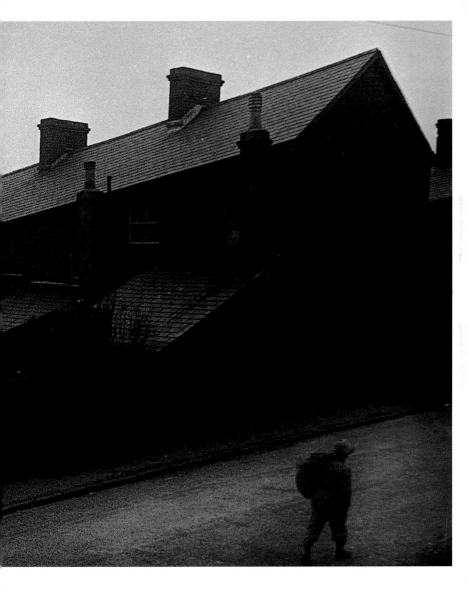

(previous page) Untitled (terraced houses, chimney-stacks, figure walking u
street), 1950. Smith's photographic legacy is not based on street scenes, bu
his archive contains hundreds of them, many similar in content to this one from
his unpublished essay 'Great Britain'. This image – of a man walking with hi
head down, a pack on his back, amid a row of terraced housing, with a billowin
chimney providing evidence of heavy industry in the background, and the whit
softness of clothes drying on a clothes-line – would almost fit into Smith'
Pittsburgh essay. It is an attempt by Smith to locate an individual – an
individual – in a larger community or social circumstance within which they hav
little control. In this essay, Smith also photographed the Prime Ministe
Clement Attlee, and his government, creating the sort of multi-faceted portra
that would find maturity in Pittsburgh.

Three Generations of Welsh Miners, 1950. This image also comes from th
'Great Britain' series, a portrait of three generations of Welsh coal miners afte
a day's work in the mines. In a conversation many years later, Smith said of thi
picture: 'The Welsh Miners was just kind of a moving in and composing a pictur
behind them, and as they came into the right composition I had my assistant ca
out to them. That's why they have quizzical faces. They turned. I think I made tw
quick exposures and that was it.'

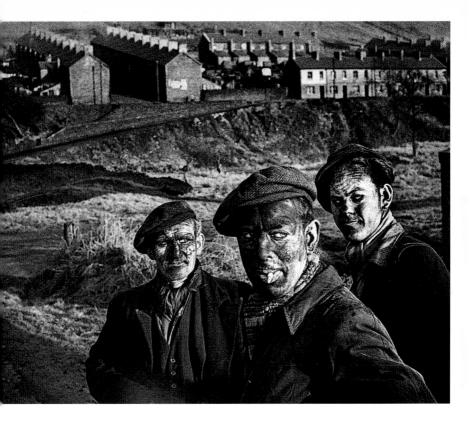

The Spinner, 1950. In 1950, Smith went to Deleitosa, near Spain's western border, to create a photo-essay on an ordinary Spanish village under Franco's fascist rule. As indicated in 'Taft and Ohio' and 'Great Britain', and foreshadowing the Pittsburgh essay, Smith's camera was focused less on individuals and more on the poetic interplay of various human desires as mythically manifest in daily routines and rituals. This picture of the spinner is widely considered to be one of Smith's most beautiful images, and the published essay in *Life*, 'Spanish Village' (9 April 1951), is considered a seminal event in the history of photojournalism.

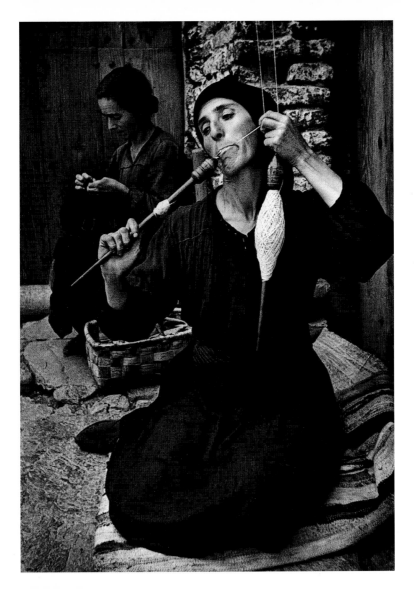

Guardia Civil, Spain, 1950. Another now classic picture from Smith' 'Spanish Village' essay. This photograph is of members of the Guardia Civil, th government-controlled military that ran political and civilian life in Spain unde Franco's rule.

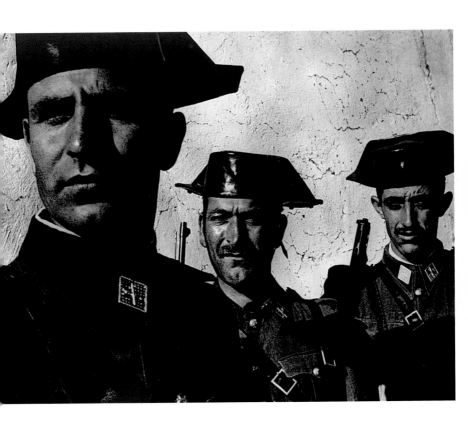

On the Outskirts, 1950. Smith's magnificent, dramatic close-ups of people, like those from 'Spanish Village', have overshadowed his landscapes, allowing many of them to be underrated. Smith's basic concern with many of his village, town and city pictures was an examination of what it means for people to congregate temporarily and permanently, for the purpose of reducing scarcity; scarcity not only of goods and services, but also of human companionship. Smith was constantly exploring relationships between individual lives and social, cultural and economic organizations.

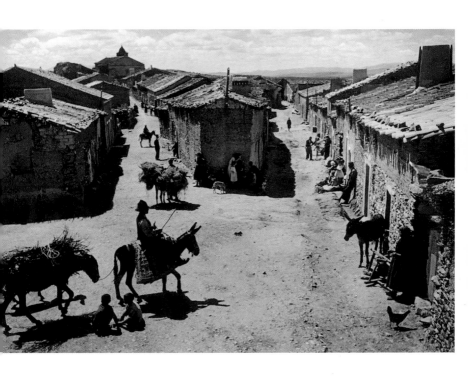

The Wake, 1950. This is another of the most enduring images of Smith's career, from 'Spanish Village', causing some critics to evoke comparisons with Rembrandt for his chiaroscuro lighting techniques, as well as the religiosity o content. However, this print is also controversial among photography purists Smith introduced a bare flash bulb into this room which had formerly been li only by candle, thus altering the nature of the intimate scene. Moreover, accord ing to Smith's biographer, Jim Hughes, he also changed the direction of the gaze of the dead man's wife and daughter by printing the eyes to black then using ferricyanide bleach to create new eye whites. Nevertheless, the image remains unforgettable.

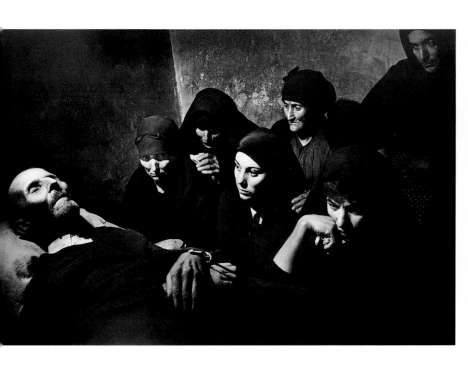

Untitled (close-up of Maude on porch holding flower), 1951. In 1951, Smith travelled to rural South Carolina and spent several weeks following Maude Callen, a black nurse-midwife, as she went about her business tending to the people of her impoverished county. Smith's eventual photographic essay 'Nurse-Midwife', published in 1951, was another landmark in photojournalism. Smith had returned to the poetic portrait of a rural carer that he had accomplished with 'Country Doctor'.

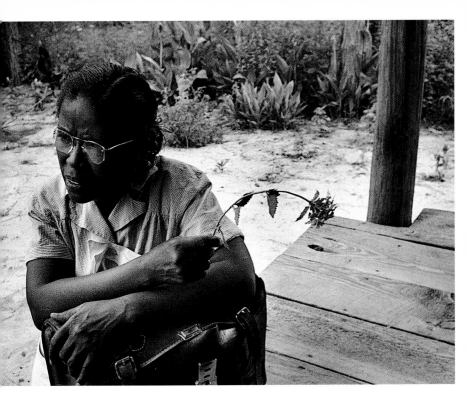

Maude – Delivery, 1951. From 'Nurse-Midwife', this is a picture of Maude Callen delivering a baby. It is a prime indication that, for Smith's photography, the exposure of the negative was just the starting point. It was his extraordinary painstaking manipulation of his negatives that brought about most of his indelible images, such as this one. Smith wrapped this picture in a circle of darkness and changed the shading of almost every element inside the circle, creating a cradle of light which emphasized Callen's face and the baby. The heartfelt essay moved many of *Life*'s readers, provoking $18,500 of unsolicited donations to Callen. The money was used to build Callen a new clinic.

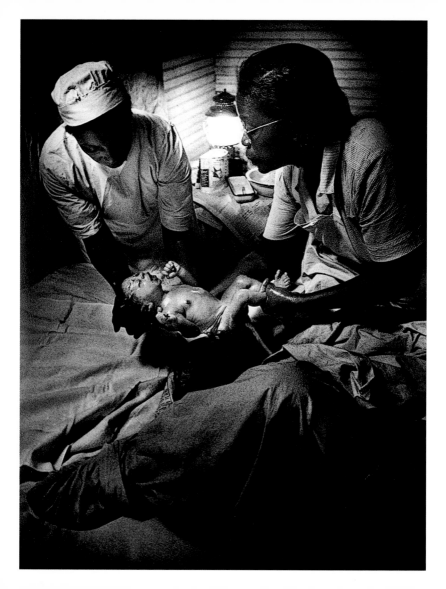

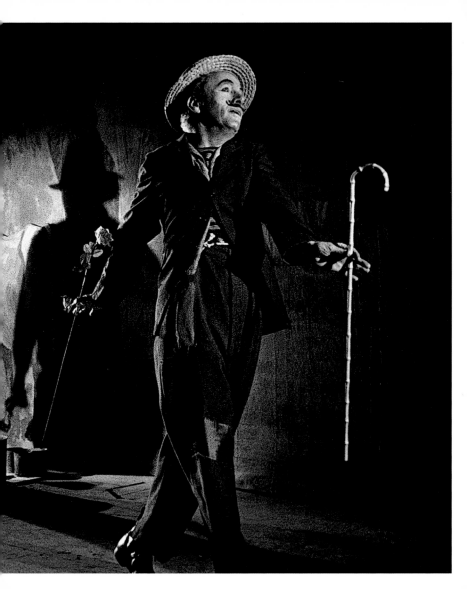

(previous page) Charlie Chaplin in *Limelight*, 1952. Like James Agee, another influence, Smith deeply admired the poetic visual sequences and deep moral convictions of Charlie Chaplin's films. Smith also admired Chaplin's dogged determination and obsessive control of his creative process. He spent several weeks on set with Chaplin while he was filming *Limelight* in 1952.

Untitled (flowing hot liquid, power lines and steam, truck and industrial shovel, locomotive on tracks), 1952. This picture is from Smith's essay 'Reign of Chemistry', which was about the giant chemical company Monsanto. Once again, Smith was exploring the ambiguous but commanding relationship between humans and their built environment and industrial endeavours. This picture also illustrates Smith's ferricyanide bleaching techniques which he used to dramatic effect, bringing light out of darkness.

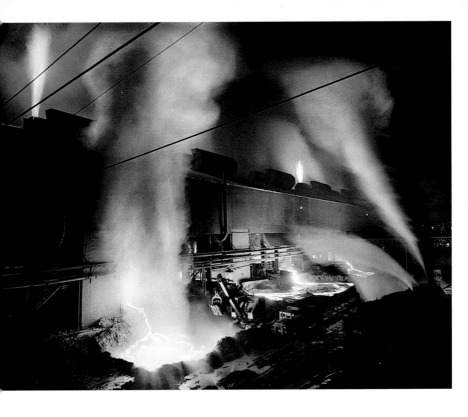

Untitled (conductor with arms raised, orchestra, reflection in mirror), 1952
This picture is from an unpublished 1952 essay on the Metropolitan Opera i
New York City. Smith was as passionate about music as he was about photogra
phy, and he often said it was his primary photographic influence. In a lecture a
the Rochester Institute of Technology on 1 January 1965, Smith said, 'Music i
not an attempt of mine to put pictures in a musical order. Music has simply bee
a teacher of mine.'

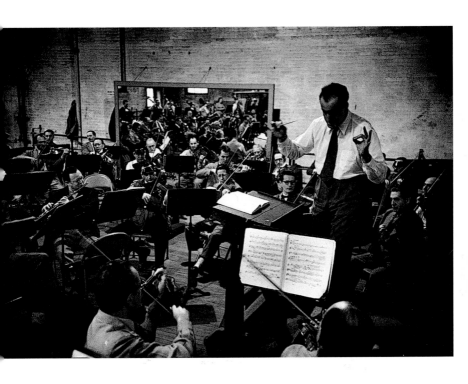

JD and his Latest Dog, Named Bozer, 1953. This photograph is from a unpublished *Life* essay on migrant farm workers in Michigan, which Smith created in the summer of 1953. He had been an admirer of the documentary study of migrant farm workers in Alabama in the 1930s, *Let Us Now Praise Famous Men*, by James Agee and Walker Evans; but he did not find the same level of conflict and despair among the itinerant family he was photographing in Michigan. His most famous works have thrived on the sort of drama and conflict absent in this work. Nonetheless, there are numerous memorable, warm images. In his picture, Smith provides a hint of the open heart he always had for household pets.

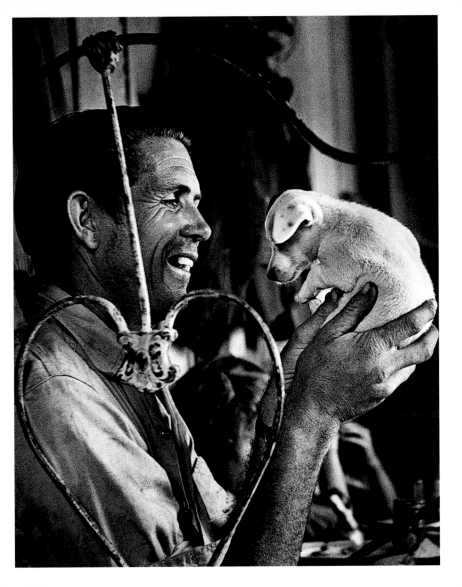

Dr Albert Schweitzer Marking Timbers During Construction Project, 1954

In 1954, Smith travelled to Lambarene, West Africa to photograph the medical compound of Dr Albert Schweitzer, who had won a Nobel Peace Prize in 1952 for his humanitarian efforts there. After many months and thousands of photographs, Smith came away with a complex portrait of what he saw as an enigma in the man and the village. This famous picture illustrates the difficulty Smith had rendering the situation of Schweitzer: the hand and saw handle in the lower right-hand corner were superimposed from at least one additional negative. The foreground–background juxtaposition of people is, once again used to masterly, poetic effect.

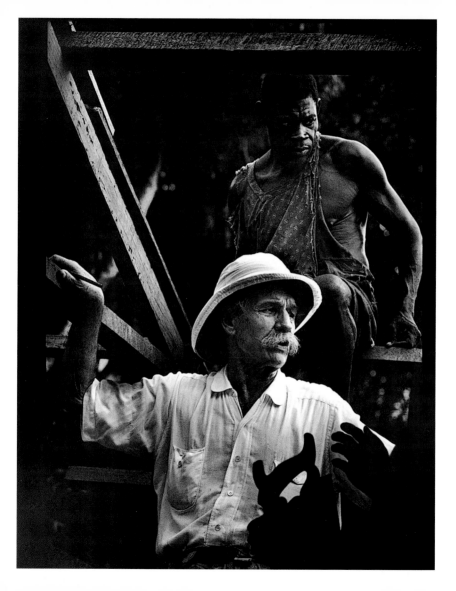

Untitled (four men carrying section of narrow-gauge railroad), 1954. Thi picture is also from the 'Schweitzer' essay. Despite Smith's disavowal of an particular religious faith, religious imagery is one of the prevalent themes of hi work. The critic John Berger has said that Smith is essentially a religiou photographer, with biblical tensions between good and evil in his work. Smith' mother, Nettie, was a devout Catholic and her written correspondence is fille with her evangelical laments over her son's lifestyle and chosen path. Th invocation of Christ — or christs — carrying the cross resounds in this picture.

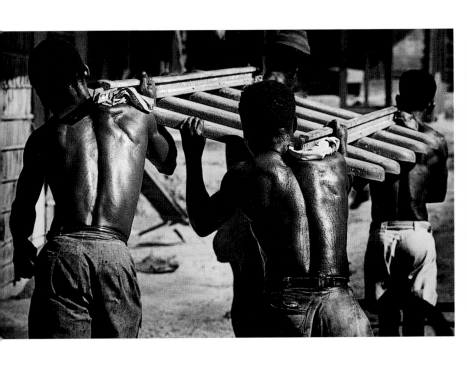

Smoky City, 1955–6. In early 1955, Smith went to Pittsburgh for a three-week freelance assignment. He responded with more than 13,000 photographs and a four-year odyssey to print and lay out his *magnum opus*, a kaleidoscopic essay of the city. Smith's painstaking, painterly printing techniques, as well as the mythic manifestations of clouded human strivings he found in the built environ-ment, are never more evident than in this picture. Smoke from the steel mill clouds the scene, yet the sky is relatively light above, and several key details are allowed to come through. A tower, called the 'Cathedral of Learning' at the University of Pittsburgh, rises above the smoke in the top left quadrant of the picture, and two spires from a church are seen enclosed by the smoke in the top right quadrant.

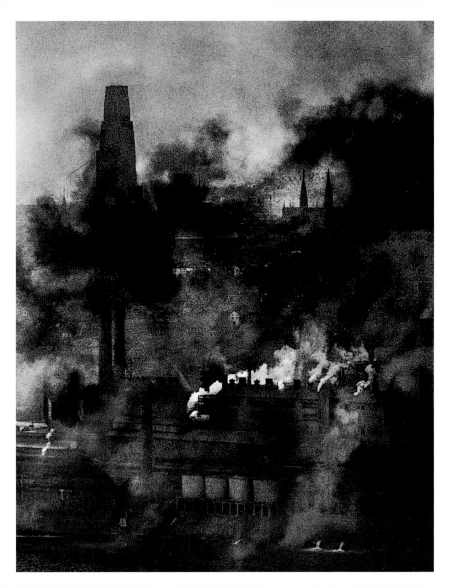

Pride Street, 1955. As Smith toured Pittsburgh through 1955 and parts c 1956, he made hundreds of photographs of street signs. Several years i advance of America's civil rights movement, the power and beauty of this photo graph needs no explanation. Throughout his career, Smith had an uncanny wa of making photographs of children that were not cute, or doting. He made the look like real, earnest people.

Dance of the Flaming Coke, 1955. Another of Smith's remarkable Pittsburg prints. A mill worker is putting the lid on the top of a coke oven. Once again, the questionable relationship between humans and their industrial quests is brought up: which is governing which? But the overriding impact of this image is made by the beauty of Smith's print. Legend has it that the obsessive Smith would sometimes take several days and an average of 15 steps or 'moves' (burning, dodging, bleaching, etc.) with one print. With this print, the legend is believable.

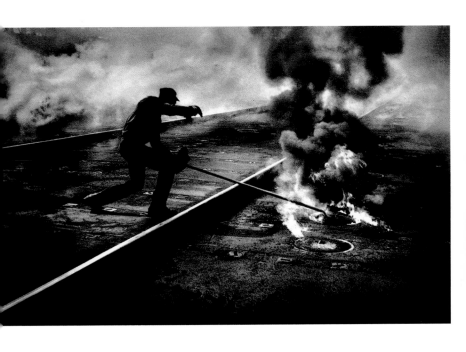

Pittsburgh, 1955–6. In a sense, this picture could be seen as a pessimist sequel to Smith's famous *The Walk to Paradise Garden*. Here the grown man alone, walking away from the camera in a tunnel of light at the bottom of a hi surrounded by monolithic darkness, literally and figuratively, in the form of dra tightly packed rowhouses. It is unclear whether or not the man is walking int the light or the dark. Smith intended his Pittsburgh essay to have a sectio called 'Ballads of the Alone', in which several images of solitary figures are see juxtaposed with layers of dwellings on a hillside.

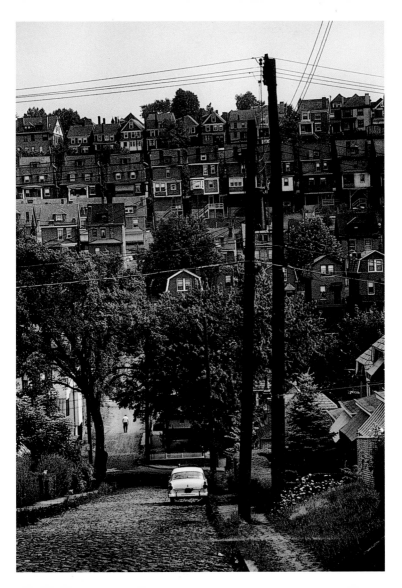

(previous page) Dream Street, Pittsburgh, 1955. If there is one theme whic[h] encapsulates the maturity of Smith's obsessive photographic mission, a[s] indicated by his Pittsburgh project, it is the rendering of human dream[s] and contemporary myth-making. Smith was concerned with the human efforts [of] dream fulfilment by a whole range of earthbound endeavours. How fitting [it] must have been for him to find a literal Dream Street in Pittsburgh. Ironicall[y] perhaps fittingly, Dream Street is not found on maps of the city today. Th[e] area where the short street used to be is grown over with bushes, trees an[d] other vegetation.

Untitled (girl holding branch watching two girls pick blossoms), 1955–[6] A major, undeclared – by him – chapter of Smith's multi-faceted Pittsburg[h] study is the series of portraits of the city's children, often put in positions [of] preference to those of the city's adults. The adults, especially the men, are ofte[n] seen as foils to the gainful exercises of heavy industry or bureaucracy, while th[e] children are seen as mindful of the more intangible, enjoyable things in life.

Pittsburgh, 1955–6. Smith's never-completed essay of Pittsburgh contained series of pictures dedicated to life at night in the city. Smith was curious about how the rhythms of the city changed when the sun went down, if they did at all. In this picture, the windows from the residences seem to watch over the activity at the hot dog stand below. The group of people is a mix of those alone and together, which could actually be the title of this body of work, 'Alone and Together'.

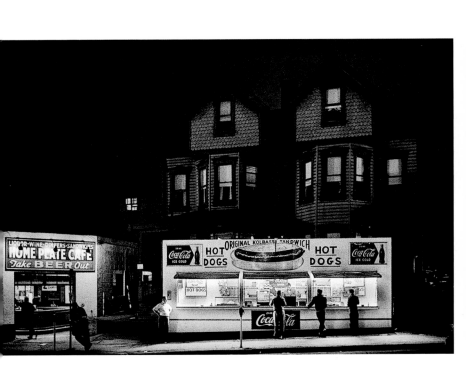

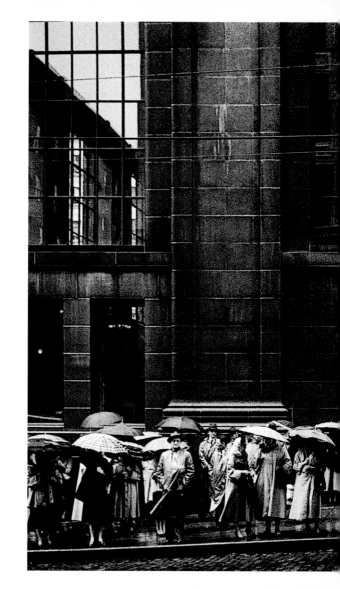

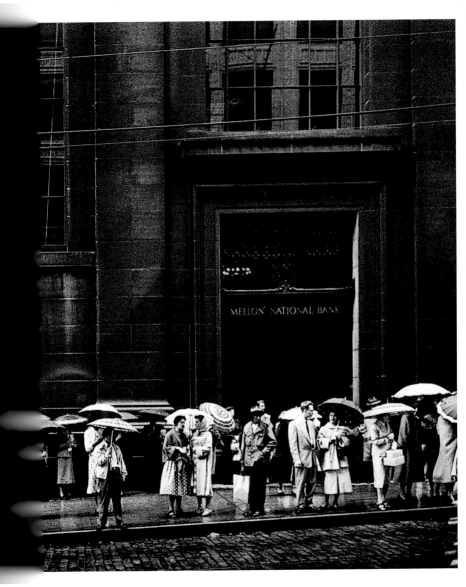

(previous page) Untitled (people with umbrellas standing on sidewalk in front of bank), 1955–6. 'Many Togethers' is another stated chapter in Smith's episodic portrayal of Pittsburgh. Formal and informal groupings of people, and the effluvium – natural or human-made – which brought them together, were favourite subjects.

Waiting for Survivors, Andrea Doria, 1956. In the summer of 1956, while Smith was deep in the throes of his Pittsburgh crusade, busily printing and laying out this essay, an Italian ocean liner, *Andrea Doria*, sank in the Atlantic Ocean. The survivors returned to New York on a rescue vessel. Smith made this poignant portrait of a nun waiting for the survivors.

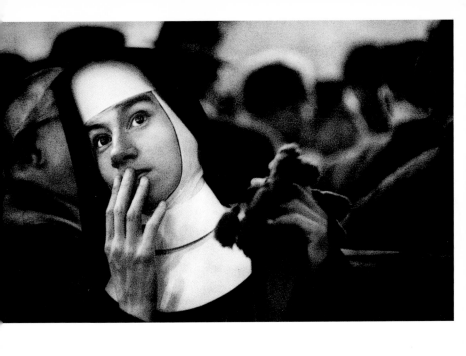

Isle of Tortuga, 1958. At the end of his Pittsburgh ordeal in 1958, Smith went to Haiti for yet another photographic project on a medical-related story: a psychiatric research hospital financed by American pharmaceutical companies for the purpose of studying the treatment of mental illness with drugs. Of course, Smith went far beyond his original assignment and created a multi layered series of pictures rendering the political and cultural climate of the country. As in 'Spanish Village' and 'Schweitzer', Smith portrayed the common nobility of the natives.

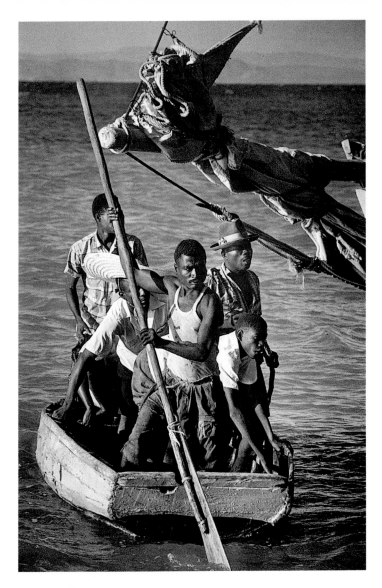

Madness, 1959. This picture of a female mental patient is the most famous (or infamous) image from Smith's 'Haiti' series. It illustrates his sometime radical distortion of a negative in the printing process, darkening everything in this image, and bringing out faces and eyes to dramatic, perhaps discomforting effect.

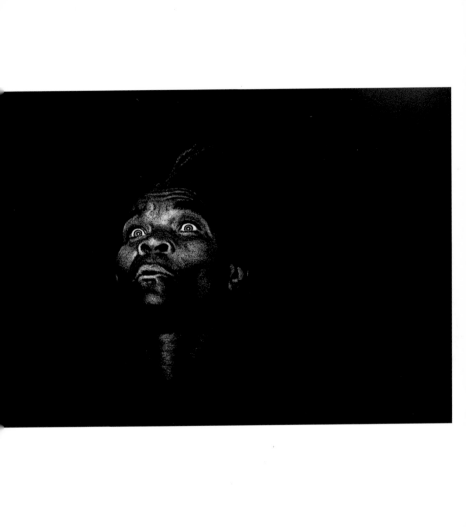

(previous page) Snow Tracks, 1957–8. In 1957, while mired in his obsessive quest to create a *magnum opus* with his Pittsburgh pictures, Smith moved out of the home he shared with his wife and four children outside New York City and into a dilapidated loft in Manhattan's wholesale flower district. There, from his fourth-floor window, Smith snapped some 15,000 pictures over the next few years. After wandering the labyrinths of a city like Pittsburgh, Smith documented one plot of New York as if he were a biologist surveying one acre of woods or pasture, watching life busily criss-crossing the sidewalks and streets below. Smith called this body of work 'As From My Window I Sometimes Glance ...'.

Loft, Outside my Window, 1957–8. This complex picture was taken from Smith's fourth-floor window, angling down towards the street corner through a fire escape. Because these window pictures lack the kind of penetrating focus that is profoundly evident in his classic works, such as 'Country Doctor' or 'Spanish Village', they have often been neglected, or even disparaged as evidence of his personal pathologies, following his Pittsburgh odyssey. But there is a certain poetry to the randomness of these pictures: the pulse of a city street and the spontaneous arrangement of people. This body of work is significant if for no other reason than Smith was prohibited, by the distance of his fourth-floor window, from posing or predetermining his images – at least not to the degree he had in previous work.

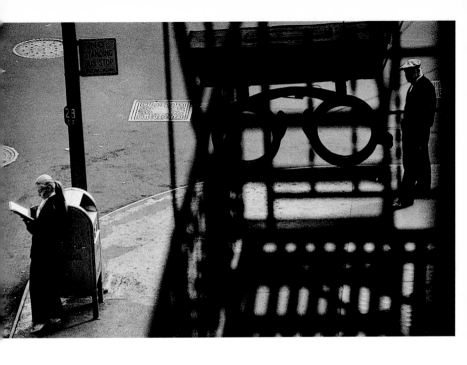

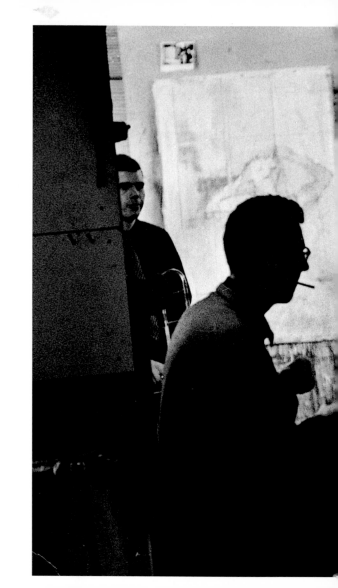

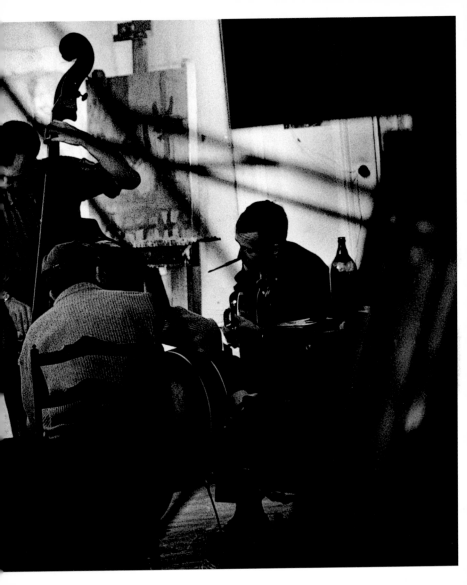

(previous page) Untitled (from the series 'The Loft From Inside In'), c.1958–68. The loft in Manhattan's flower district, where Smith moved in 1957, happened to have been a haunt of jazz musicians since 1954. Musicians regularly climbed the loft stairs for jam sessions in the middle of the night. In addition to the thousands of pictures he made from his fourth-floor window, Smith turned his camera to the interior of the loft, making some 20,000 photographs in a series he called 'The Loft From Inside In'. Many of these pictures are focused on the jazz musicians and all but a few of them are 5 x 7 work prints which have never been published. Given Smith's obsessive printing processes, his work prints are often near final print quality. This work print is of guitarists Jim Hall and Jimmy Raney and bassist Bill Crow taking part in a session on the fifth floor which was occupied by abstract expressionist painter David X. Young.

Thelonious Monk, c.1959. Legendary jazz pianist Thelonious Monk was a frequent visitor to the loft, working there with his longtime collaborator musician Hall Overton, another loft resident. Smith was a fan of Monk's dissonant harmonies and topsy-turvy chords, and he snapped hundreds of photographs of him working with Overton and rehearsing with his bands in the loft. Monk's album *MONK* was re-released in the mid-1960s (Columbia Records) with this finished picture as its cover. Smith made this picture one night in 1959 when Monk's entire 10-piece band was in the loft practising.

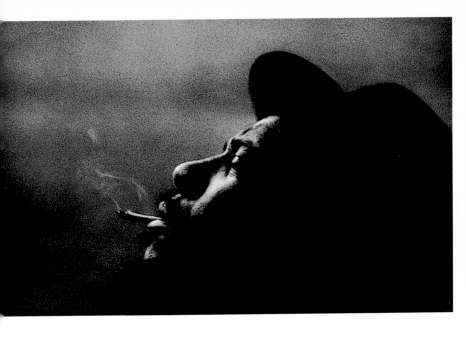

Untitled (from the series 'The Loft From Inside In'), c.1958–68. This is a wor
print of trombonist Vic Dickenson, clarinetist Pee Wee Russell and drumme
Ronnie Bedford in the hallway of the delapidated loft. It was a jazz crossroads
a place of musical and personal exchange in the days before jazz was commonl
accepted as worthy of university study and concert hall repertory. Smith's
documentation of this scene extended beyond his photographs. He wired the
building like a studio and made 418 reel-to-reel recordings of the sessions. A
a time in his life that Smith later called 'the worst', the scene seemed to
sustain him.

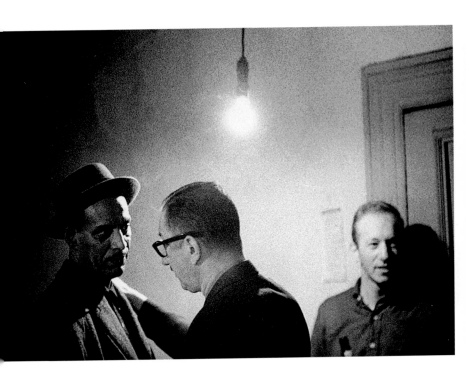

Untitled (saxophonist, woman in background with head tilted), c.1960s. 'I was once present at a lecture that Eugene Smith gave to some students at a school of photography,' said Henri Cartier-Bresson. 'At the end, they protested because he had made no mention of photography, but had spoken the whole time about music. He calmed them down by saying that what was valid for one was valid for another' (*Henri Cartier-Bresson and the Artless Art*, Jean-Pierre Montier). This finished picture is of saxophonist Zoot Sims and an unidentified woman. It is an example of how Smith uses relationships within a picture frame to create rhythm.

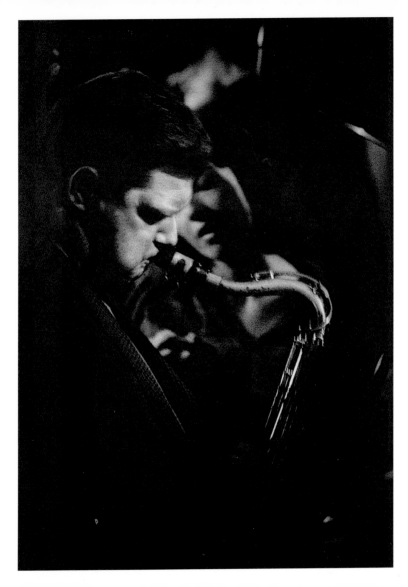

Untitled (from the series 'The Loft From Inside In'), c.1958–68. This work prir
is from painter David X. Young's fifth-floor studio in the loft building, and th
paintings in the picture are Young's. Fragments and juxtapositions were such
big part of Smith's aesthetic at certain times, that some of his pictures have
hint of cubist formality. The guitarist partially pictured here is Jimmy Raney.

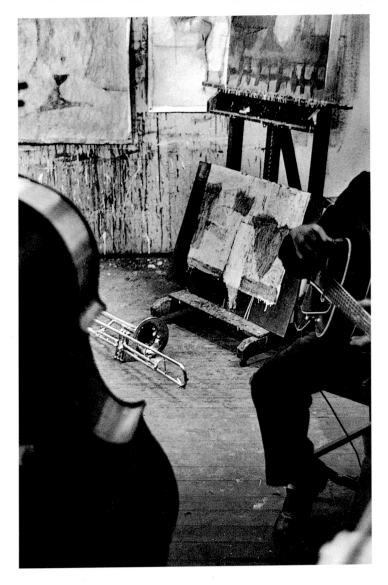

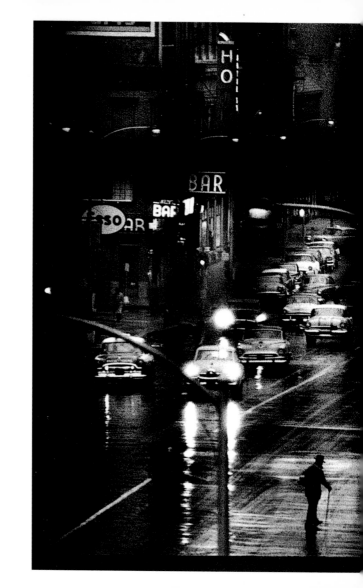

(previous page) White Rose Sign, 1957–8. This is another picture taken from the fourth-floor window of the loft building. Smith's common, solitary figure walking amid the bustle or enormity of a city resurfaces again. The sign in the bottom right-hand corner is of the White Rose Bar, which was where the jazz musicians who came to the loft often went for a drink or something to eat.

Untitled (two men working on equipment on utility pole), 1961. In 1961, Smith was hired by the electronics manufacturer Hitachi to go to Japan for a year and photograph the company and the proud industrial landscape surrounding it. Once again, Smith had licence to aggressively pursue his ongoing visual examination of the enigmatic mix of human, cultural, economic and individual affairs. This time, the subject of Japan added another level to his intrigue sixteen years after he was almost killed by a bomb while photographing combat there in World War II. The lure of Japan continued until a decade later, when Smith returned to create his world-famous portrait of the village of Minamata.

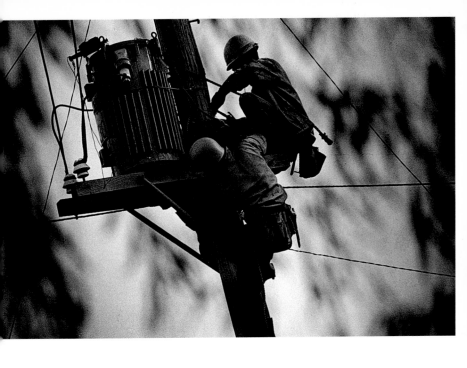

Untitled (woman hoeing weeds by wheels of enormous vehicle), 1961–2. This is another picture in the 'Hitachi' series. The Hitachi project is a lyrical study of the contrast between the deep cultural roots in Japan and the aggressive industrial build-up then taking place. It bears resemblances to Smith's Pittsburgh work. In 1963, Hitachi published 144 of these pictures in an obscure book entitled *Japan: A Chapter of Image*, and on 30 August of the same year *Life* magazine published 13 of the pictures. In America, only a few of the Hitachi pictures have ever been published; this is another of Smith's large, unsung bodies of work.

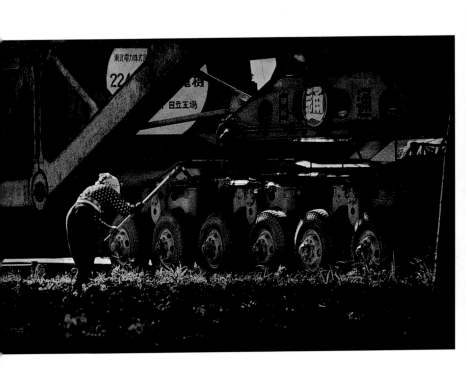

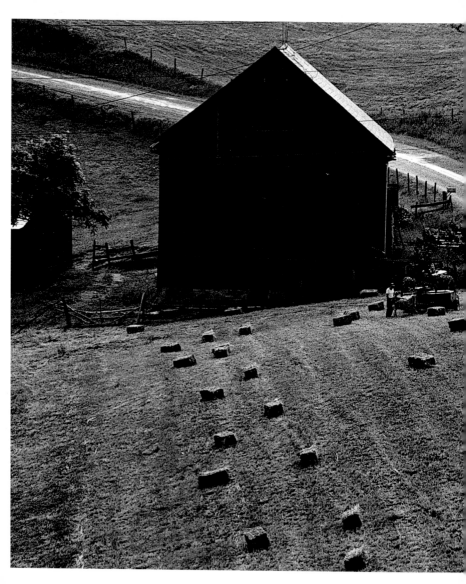

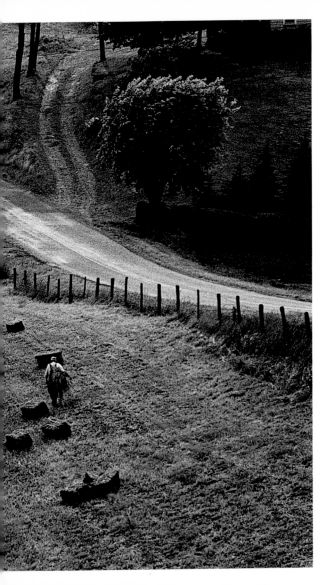

(previous page) Untitled (baled hay in field, two men and tractor, barn, road with forking lane), 1969. Again, Smith is not famous for his landscape photographs, but his archive contains many outstanding ones. This one is from Bealesville, Ohio in 1969. As in many of his landscapes, people appear working humbly in this picture and there is a road – made lighter by Smith's darkroom techniques – dissecting a portion of the frame.

Fishing in Minamata Bay, c.1972. From the standpoint of public acclaim for new work, the decade of the 1960s was lost for Smith; but a monograph published in 1969 and a massive retrospective exhibition at the Jewish Museum in New York two years later revived him. Smith and his Japanese-American second wife, Aileen, accompanied the exhibition to Japan in 1971. While there, they learned of the mercury-poisoned fishing village, Minamata. Smith found the village and its saga to be the perfect subject for what would be the epic, tragic conclusion to one of the ongoing themes of his life's work: the paradoxical relationships between humans and human-made economic and social endeavours and institutions.

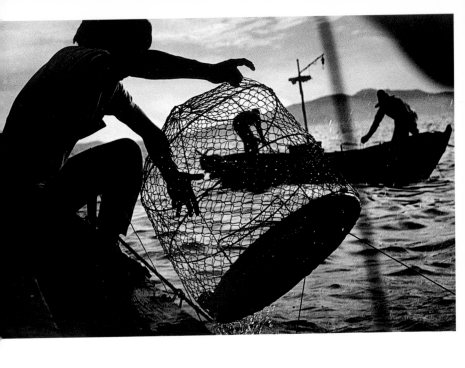

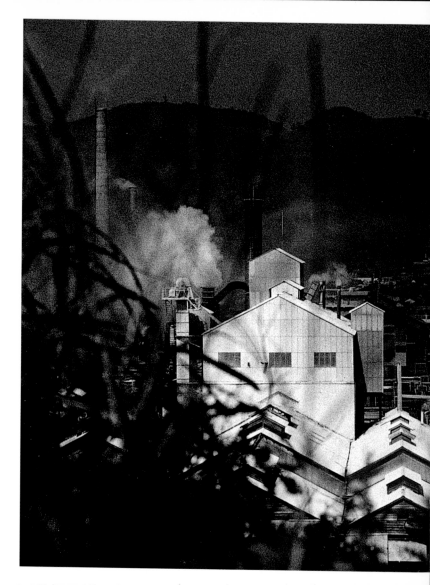

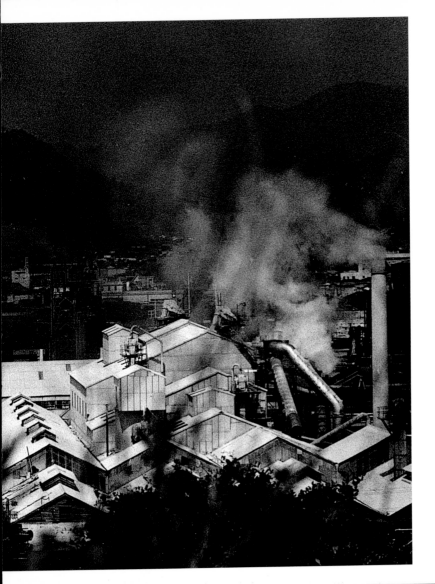

(previous page) Untitled (overview of Chisso factory buildings, grass i
foreground), c.1972. In this picture, the white buildings of the manufacturin
company Chisso, which was responsible for dumping mercury into the waters of
Minamata's coast, sit hauntingly behind a foreground — a sheath — of grass an
vegetation. Smith's pessimism and outrage, which before was tempered by
melancholy lyricism and irony in works such as 'Pittsburgh', came through fu
throttle in 'Minamata'. He made no pretence of picturing Chisso as anythin
other than an enemy to basic moral concerns.

Newsmen Covering Environmental Minister Takeo Miki's Tour of Minamata
c.1972. In Minamata Smith saw the sufferings and struggles of individual
against the tide of institutional concerns manifested in dramatic publi
manners. Themes which Smith brought to bear throughout his career wer
given a final, dramatic presentation with this work.

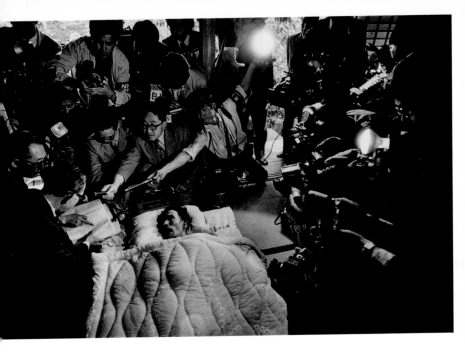

1918 Born 30 December in Wichita, Kansas.

1924–1935 Attends Catholic elementary and high schools in Wichita. Introduce to photography by his mother, he starts making pictures, mainly fo local newspapers. At the age of fifteen, his picture of the drought dried bed of the Arkansas River is published by the *New York Times*.

1936 Father commits suicide following failure of family business in th Great Depression. Wins scholarship to study photography a University of Notre Dame, Indiana, but drops out after a year t become a full-time professional photographer in New York.

1937 Becomes staff photographer on *Newsweek* magazine.

1938 Leaves *Newsweek* and freelances for Black Star Agency. Wor appears in *Life*, *Colliers*, *Harper's Bazaar* and *Time*.

1942 Joins staff of *Life* magazine but resigns after a year.

1943 Joins staff of *Parade* magazine.

1943–1944 Fails attempt to join Edward Steichen's naval photography uni but joins staff of *Flying* magazine as correspondent/photographer Photographs many combat missions.

1944–1945 Returns to *Life* as correspondent/photographer in South Pacific Badly wounded by shellfire in Okinawa. Disabled for more than a year.

1946–1954 Works as staff photographer for *Life* magazine and produce landmark photo-essays such as 'Nurse-Midwife', 'Spanish Village and 'Country Doctor'.

1955 Resigns from *Life* and becomes member of Magnum Photo Agency Contributes to *Life*, *Sports Illustrated*, *Popular Photography*. Hi photograph *The Walk to Paradise Garden* is used as closing image i Edward Steichen's 'Family of Man' exhibition at Museum of Moder Art, New York. Embarks on major project on Pittsburgh.

1957 Moves out of home he shares with wife and four children, and move

into delapidated loft in New York's flower district. Over the next seven years, photographs jazz scene that takes place in the lofts and views from his fourth-floor window.

1961 Commissioned by Hitachi, goes to Japan for a year to photograph the company.

1965 With assistant Carole Thomas develops the visual arts and literary magazine *Sensorium*, but it is never published.

1965–1969 Teaches and lectures at various schools and symposiums. Awarded a rare third Guggenheim Fellowship.

1969 Publishes *W. Eugene Smith: His Photographs and Notes*.

1971 Creates 642-picture retrospective exhibition 'Let Truth Be the Prejudice', at the Jewish Museum, New York. Exhibition later travels to Japan. He and second wife, Aileen Sprague, accompany it. Discovers story of Minamata and documents it in what becomes his most famous essay.

1975 Publishes *Minamata* to worldwide acclaim.

1977 Suffering from poor health, he moves from New York to Tucson to teach at Center for Creative Photography, University of Arizona.

1978 15 October, dies from a stroke, aged fifty-nine.

Photography is the visual medium of the modern world. As a means of recording, and as an art form in its own right, it pervades our lives and shapes our perceptions.

55 is a new series of beautifully produced, pocket-sized books that acknowledge and celebrate all styles and all aspects of photography.

Just as Penguin books found a new market for fiction in the 1930s, so, at the start of a new century, Phaidon **55**s, accessible to everyone, will reach a new, visually aware contemporary audience. Each volume of 128 pages focuses on the life's work of an individual master and contains an informative introduction and 55 key works accompanied by extended captions.

As part of an ongoing program, each **55** offers a story of modern life.

W. Eugene Smith (1918–78) is widely acknowledged as the 'master photo-essayist of his generation'. He declared that his mission in life was nothing less than to document, in words and pictures, the human condition. The landmark photo-essays 'Country Doctor', 'Pittsburgh' and 'Minamata', featured in Phaidon's **55**, are just part of his massive legacy.

Sam Stephenson is a writer and lecturer at Duke University, North Carolina. He has been awarded a Fellowship from the US Endowment for the Humanities for his research on the life and work of W. Eugene Smith.

Phaidon Press Limited
Regent's Wharf
All Saints Street
London N1 9PA

Phaidon Press Inc.
180 Varick Street
New York NY 10014

www.phaidon.com

First published 2001
©2001 Phaidon Press Limited
©Photographs: The Heirs of
W. Eugene Smith
©Minamata photographs:
Aileen M. Smith

ISBN 0 7148 4035 1

Designed by Julia Hasting
Printed in Hong Kong